W9-AUD-330

My Best Friend Will

My Best Friend Will

Jamie Lowell & Tara Tuchel

Foreword by Pamela Wolfberg

112902 – Jan 2010

APC

Autism Asperger Publishing Co.
P.O. Box 23173
Shawnee Mission, Kansas 66283-0173
www.asperger.net

AAPC

© 2005 by Autism Asperger Publishing Co.
P.O. Box 23173
Shawnee Mission, Kansas 66283-0173
www.asperger.net

Publisher's Cataloging-in-Publication
(Provided by Quality Books, Inc.)

Lowell, Jamie.
 My best friend Will / Jamie Lowell & Tara Tuchel.
 p. cm.
 Includes bibliographical references.
 SUMMARY: Will has autism. Even though that makes him different in some respects, like all kids he likes to have friends. Jamie is his best friend.
 Audience: Grades: Kindergarten-late elementary.
 ISBN 1931282757
 LCCN: 2005923958

 1. Autism—Juvenile literature. [1. Autism.
2. Friendship. 3. Best friends.] I. Tuchel, Tara.
II. Title.

RC553.A88L69 2005 616.89'82
 QBI05-800245

This book is designed in Gigi and Helvetica Neue.

Photography by Berard Portrait Design, Hudson, Wisconsin.

Printed in South Korea.

Dedication

This book is dedicated to my family, who support me in all of my endeavors in a career that I am passionate about. Mom, dad, Nate, Sophie, Claire, Max, Mandy and Jaime – your love means the world to me. To my loving husband, Greg, who has been by my side through it all.

I also want to thank the phenomenal students and staff at Willow River Elementary, who have fostered an accepting and caring environment for all children. It is because of you that we have learned to go beyond merely tolerating differences, and have come to embrace them. Kudos to my fabulous educational assistants who play an integral role in the education of all of my students.

Thanks to Pamela Wolfberg (founder of Integrated Play Groups), who is a mentor and a friend, and whose work has been an inspiration to me. This book would not have been possible without Integrated Play Groups or Pamela's guidance.

Sue and Jeff Roberts are wonderful parents who have found a balance between accepting their son Willie for who he is and pushing him to reach his potential in all areas of development. You have taught me so much over the past 6 years and for that I am forever grateful.

My most sincere appreciation and respect goes to Jon and Kathy Berard, who have created the priceless images that grace this book. Your talent never ceases to amaze me.

Finally, special thanks to Jamie and Willie, who surprise me every day with their accomplishments and their unconditional acceptance of one another. You are both a shining example to many!

—Tara Tuchel

This book is dedicated to my friend Willie, who taught me how to understand differences in people. I also want to thank all of the teachers who help Willie every day. Thank you for including me in Integrated Play Groups with him! My family has helped me to put this book together and I love them a lot. All of my friends at Willow River Elementary have been very nice to Willie, and that is a choice that they made. I am very proud of them for that. I would also like to thank Willie's mom and dad – Sue and Jeff Roberts – for helping us get together and have fun. Also thank you to Jon and Kathy Berard for being so nice and helpful.

— Jamie Lowell

Preface

Jamie and Willie first met each other in kindergarten. I soon noticed that Jamie gravitated toward Willie and was very accepting of him, even though he did not seem very interested in other children at the time, including Jamie. In order to help Willie learn to play with other children, I started the Integrated Play Group program in my school. Jamie and Willie have been playing and enjoying each other's company ever since. Now in fifth grade, the two remain close friends and are very comfortable "hanging out" with each other.

Next year, a new journey will begin for the pair of friends – middle school. I'm positive that Jamie will be an advocate for her friend Willie and others with differing abilities in middle school as well as throughout life. This book chronicles their friendship, illustrating the idea of unconditional love and acceptance.

—Tara Tuchel

Foreword

*Each friend represents a world in us, a world possibly not born until they arrive,
and it is only by this meeting that a new world is born.*
— *Anais Nin*

Friendships are a most essential part of the human experience. The innate desire and need for friendships manifests in the child's earliest encounters with peers. Babies are drawn to each other like magnets, striving to make a social connection the moment their eyes meet. Brief and fleeting interactions between toddlers gradually transform into lengthy exchanges as they increasingly seek each other out for play and companionship. By preschool age, the concept of friendship begins to take shape as children navigate ever more complex social groups within their peer culture. And it is through active participation in shared activities that are highly valued by the peer culture (most notably, play) that mutual friendships are fully formed.

Fitting in and making friends can be a daunting experience for anyone with social challenges, and particularly for children on the autism spectrum. In children with autism, the brain develops differently, affecting the capacity to interact socially with others; communicate basic needs, feelings and ideas; understand and use language effectively; develop play and imagination; and form peer relationships. Although most children on the autism spectrum are no different than typically developing children in their desire for friendships, they often do not possess natural abilities to easily make friends on their own. Most typical children exhibit a high level of social competence, and thus make friends with seemingly little effort. Typical children essentially acquire the very skills that appear to be lacking in children with autism, skills that allow them to negotiate the wide range of complex behavior patterns encountered in peer groups and other social situations. Not only are they cued into the subtle nuances of social communication, they also have a keen understanding of the perspectives of others and a strong sense of the unspoken rules of the peer culture.

The peer culture plays a decisive role in determining whether or not a child is included. Without any form of preparation, most typical children are unlikely to react positively to a child who behaves in unexpected ways. The unusual manner in which many children with autism relate to people and objects often sets them apart from their peer group. For example, their subtle or awkward attempts to engage other children are frequently misinterpreted by peers as signs of deviance or

limited social interest. Consequently, they often fall victim to teasing and rejection, or are simply overlooked and neglected. Without a system of support, these children are especially vulnerable to being excluded, and thus deprived of opportunities to learn how to socialize and make friends.

From both a developmental and a psychological perspective, the lack of friendships in childhood can have devastating consequences. Research suggests that the experience of a childhood friendship provides invaluable lessons that stay with us through adulthood. Thus, children with friends have a greater sense of well-being, better self-esteem and fewer social problems in later life than those without friends. Conversely, children without friends are more likely to be victimized by peers and to have problems adjusting to school and social relations in adulthood. Moreover, children without any friends are decidedly lonelier than those with friends. Having even just one close friend, a best friend, is vital to a child's sense of self, happiness and belonging.

My Best Friend Will is a story about a remarkable friendship between two extraordinary children – Jamie (a typically developing girl) and Willie (a boy with autism). Jamie Lowell has written this story about her best friend with guidance from Willie's gifted teacher, Tara Tuchel. While many a philosopher and poet has struggled to define the true meaning of friendship, the words and photographs that grace this book reveal the answer ever so simply and sweet. Through Jamie's eyes we enter Willie's world as it unfolds at school, home and play. We come to understand and appreciate Willie's many unique qualities and to accept that these are all a part of who he is. Jamie not only teaches us what it means to have a friend like Willie, but also what it means to be a friend and how to model this for other children.

What this story does not explicitly tell us is the key to the success of Jamie and Willie's friendship – how Tara Tuchel cultivated fertile ground for this relationship to blossom by creating a culture in her classroom, school and community that embraces diversity and inclusion. Tara has brought together numerous children on the autism spectrum with typical peers in her model Integrated Play Groups program. Jamie and Willie's friendship is a powerful testimony to Tara's outstanding skill in supporting children's learning and development in the most meaningful of ways. While some friendships are transient and others ever-lasting, the friendships that Tara has nurtured in her students over the years (including Jamie and Willie's) will leave footprints on the children's hearts that will stay with them through their lifetime.

> – Pamela Wolfberg, Ph.D., assistant professor, San Francisco State University, co-founder, Autism Institute on Peer Relations and Play, and author, *Play and Imagination in Children with Autism* and *Peer Play and the Autism Spectrum: The Art of Guiding Children s Socialization and Imagination*

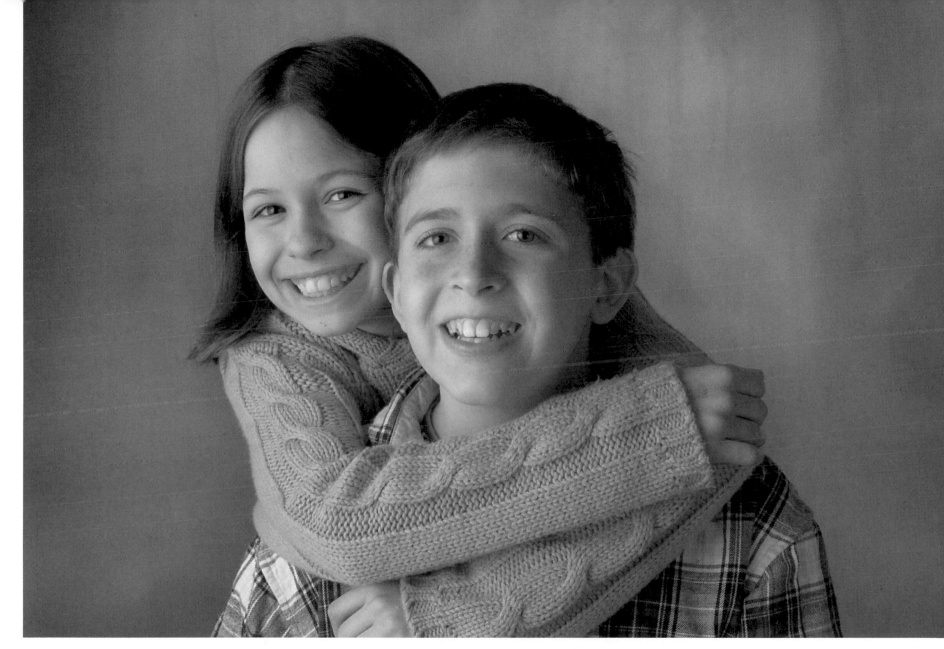

My best friend's name is Will. He has autism; that's okay. He's my best friend, because he makes me smile.

Autism is something that makes a person's brain work a little differently. Doctors and researchers aren't sure what causes autism, but they are working hard to figure it out.

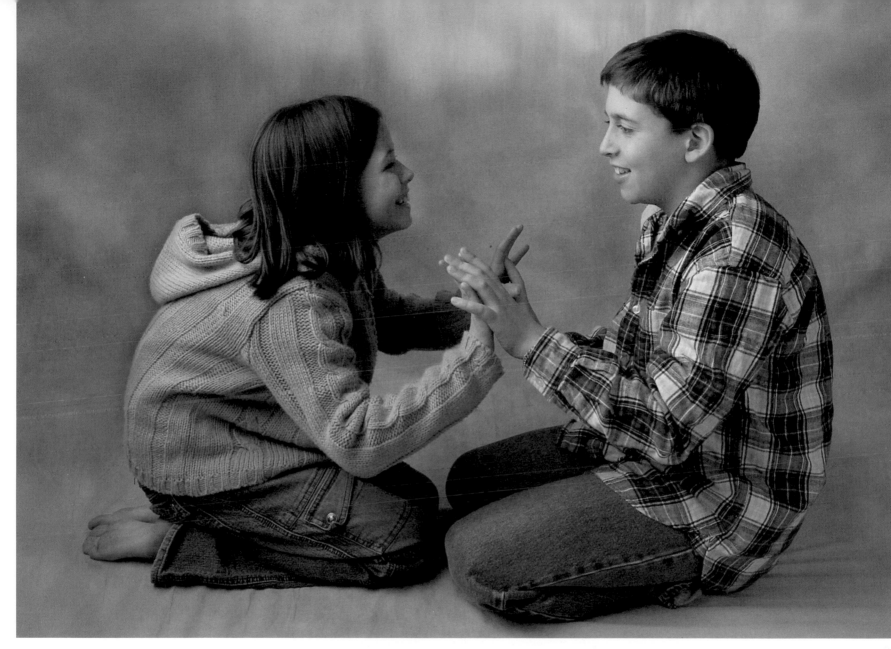

You cannot catch autism from another person; it is not contagious. Autism is just another way of being.

Some people have
different colors of hair
or eyes, and some
people have a
different way
of thinking.

Autism
is a different way
of thinking.

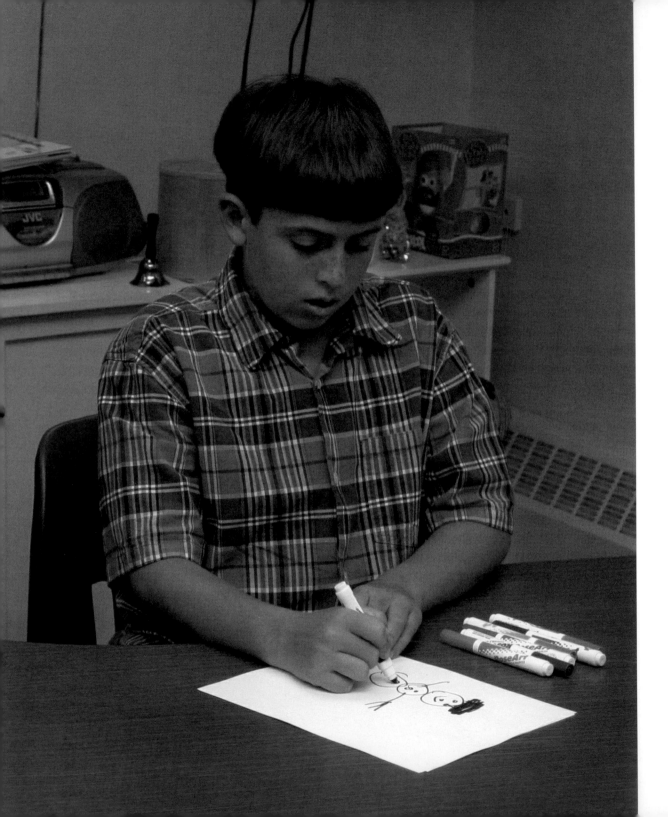

One way that my best friend Will's brain works differently is that he likes to do some things over and over again. This is called *perseveration*.

Lots of kids with autism perseverate on things. Will likes to draw snowmen over and over again. This is how Will perseverates.

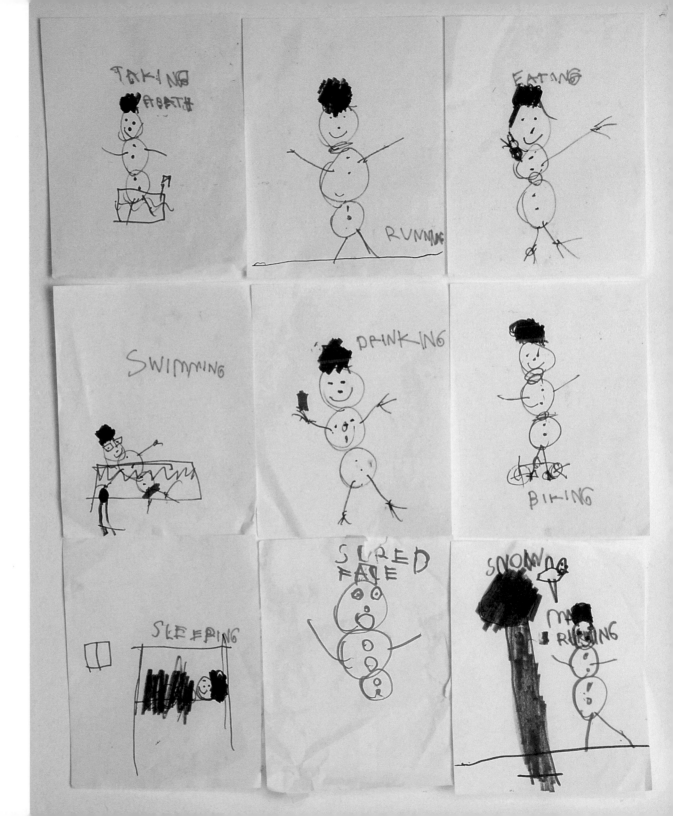

Another way that my best friend Will's brain works a little differently is that he likes things to stay the same. If there are too many changes, he can become confused or frustrated.

At school, there are days when recess gets canceled because it is raining outside. When a change like that happens, Will often gets confused because it makes his schedule different.

But there are many ways that my best friend Will is the same as me. Just like me, he has a mom and dad who love him very much.

Like lots of kids,
Will has pets.
He has two dogs.
Their names are
Walt and Disney.
Will likes to play
with his dogs.

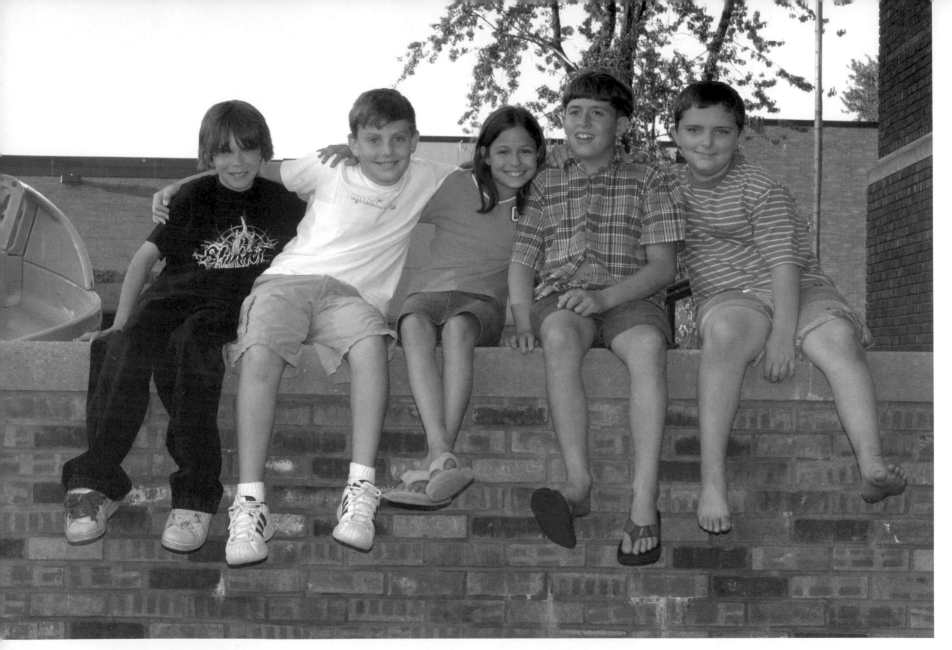

Will has a lot of friends. We all have fun playing together, just like any other friends.

We all like Will just the way he is, because he is fun to play with. One thing that we all like to do together is using a box and scooter to make a log ride at school. Some of our friends spray water on the kids in the log ride. Will really likes that.

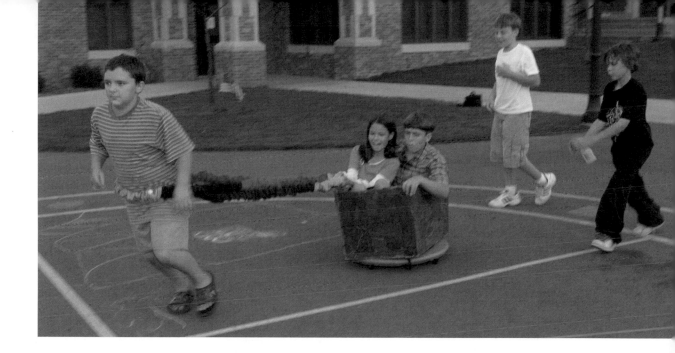

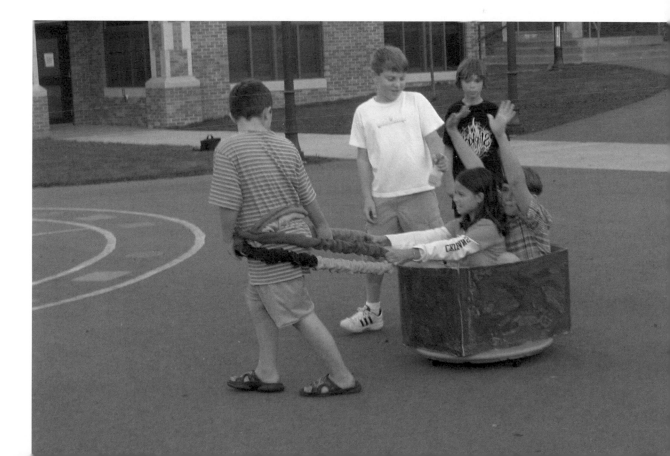

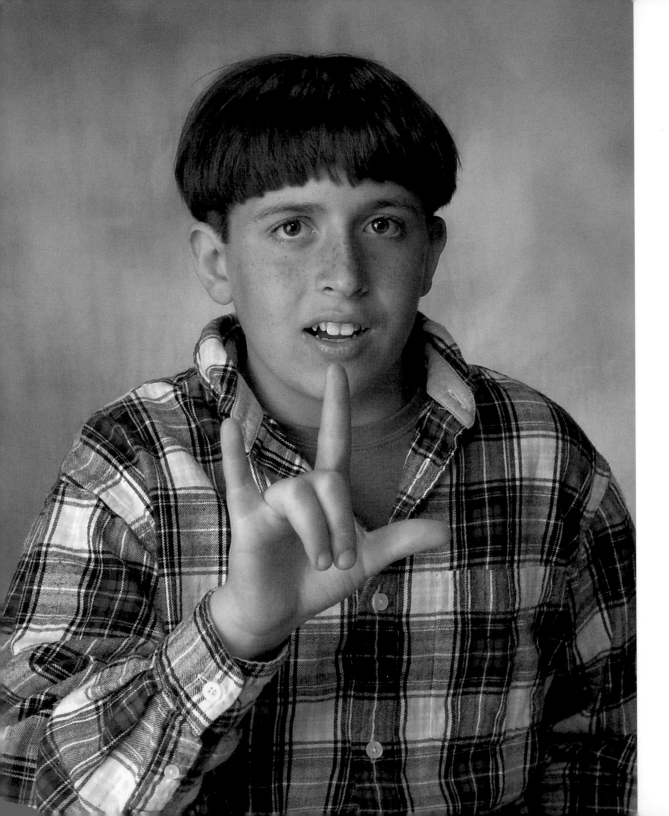

Many kids with autism have special interests. Their special interest might be washing machines, locks and keys, computers, movies or something else that they like a lot. Will is really interested in sign language.

You can ask what your friend's special interest is because he or she might love to share it with you. This is a good way to learn about your friend with autism and enjoy things together.

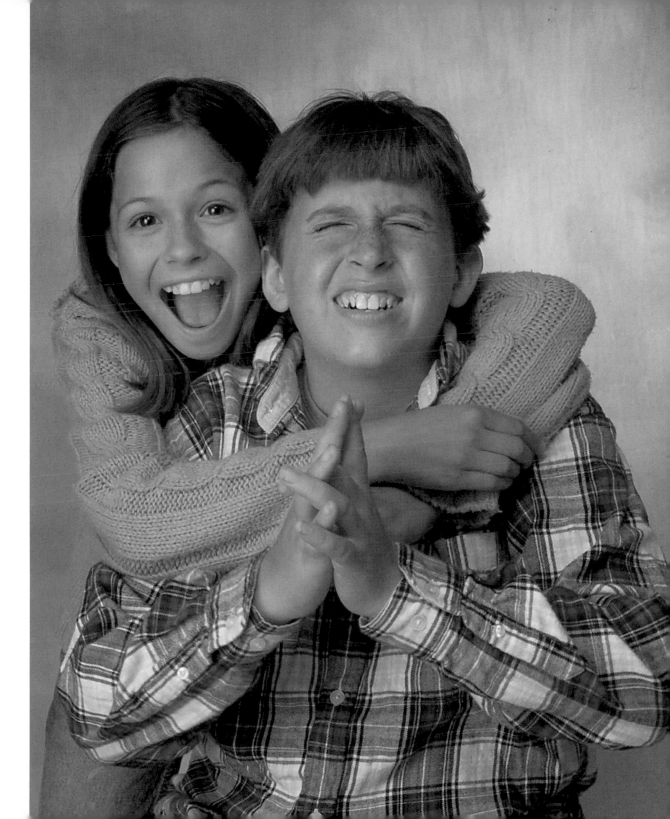

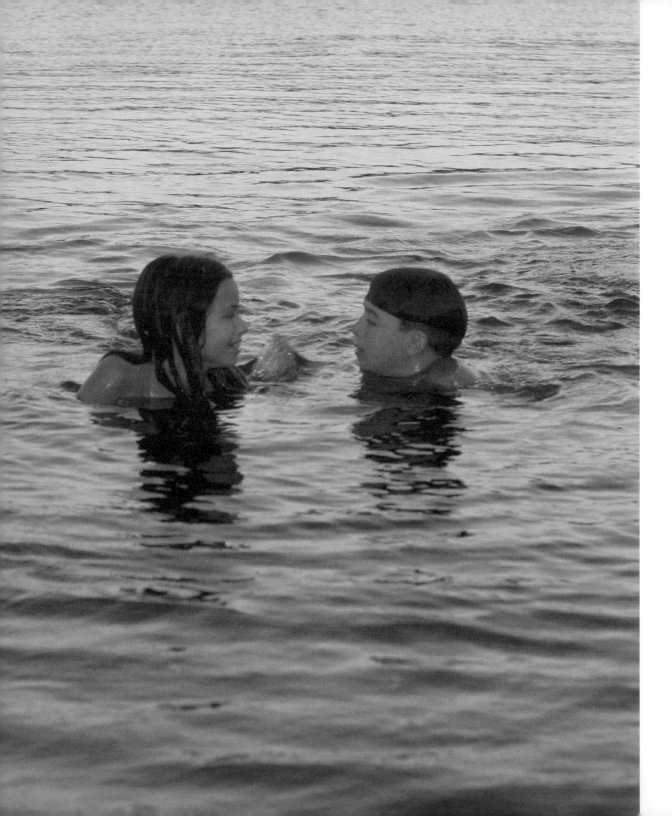

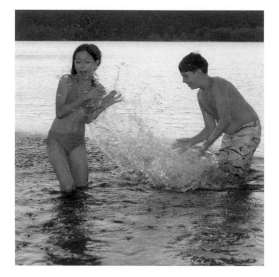

Just like me, Will has things that he enjoys. Will really likes swimming, and so do I! We have fun playing in the water together.

Sometimes kids with autism hear, see, smell, and taste things differently. This isn't wrong; it is just a different way of learning about the world.

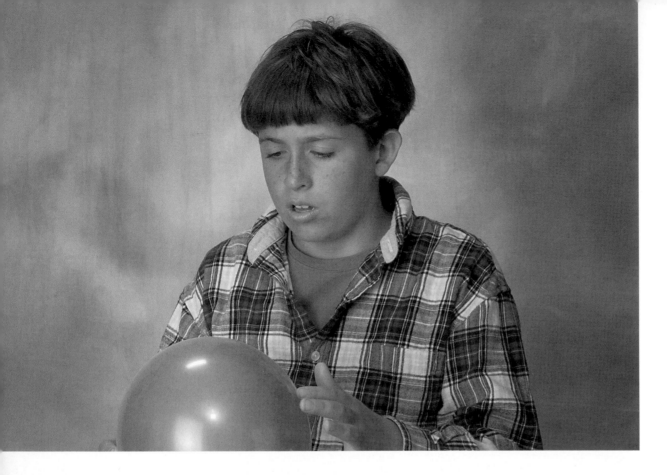

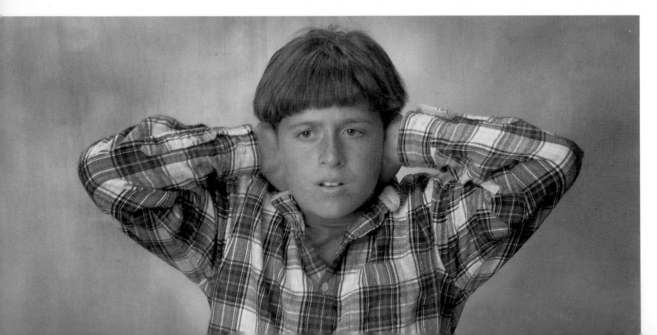

One of the things Will is scared of is a balloon popping. To him, the popping is so loud that it sounds like firecrackers going off next to his ears. Many kids with autism cover their ears when sounds become too loud for them.

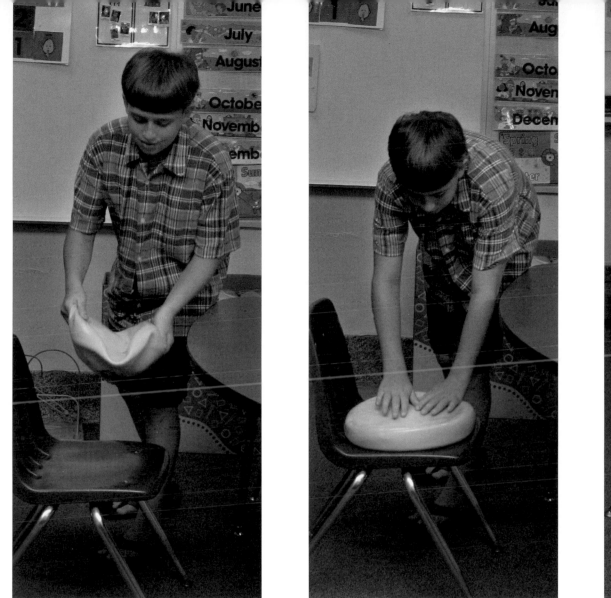

The way Will feels touch is different too. One day Will got a shock from sitting on a plastic chair. To him, it felt like getting hit by lightning. Now, he will only sit on plastic chairs if he puts a pad down first to avoid a shock.

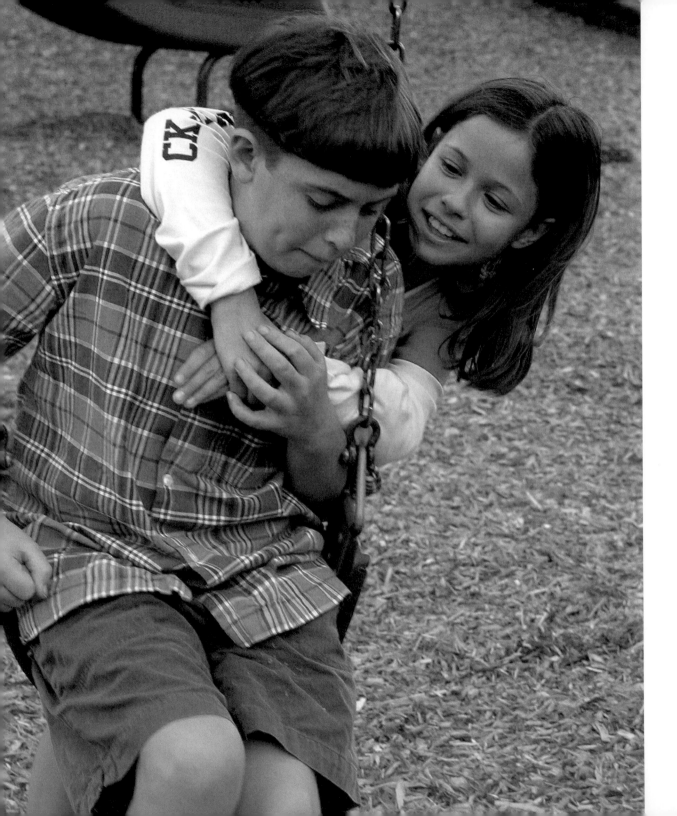

Many kids with autism feel touch in different ways. They can either feel too much touch or not enough touch.

When kids with autism feel too much touch, it might feel like someone is hitting them really hard even though the person might just be tapping their shoulder lightly.

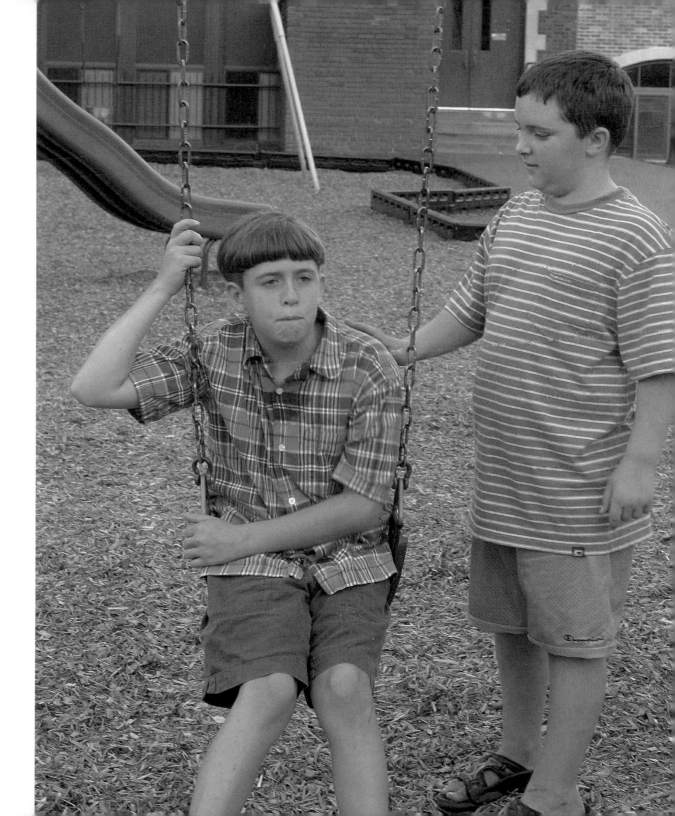

Many kids don't like to try new foods. But for kids with autism, trying new foods can make them very sad and worried. This is because their sense of taste and smell might work in a different way.

Some kids with autism can see fluorescent lights flickering. Others may be good at noticing details in things. This is how sight might work in a different way for them.

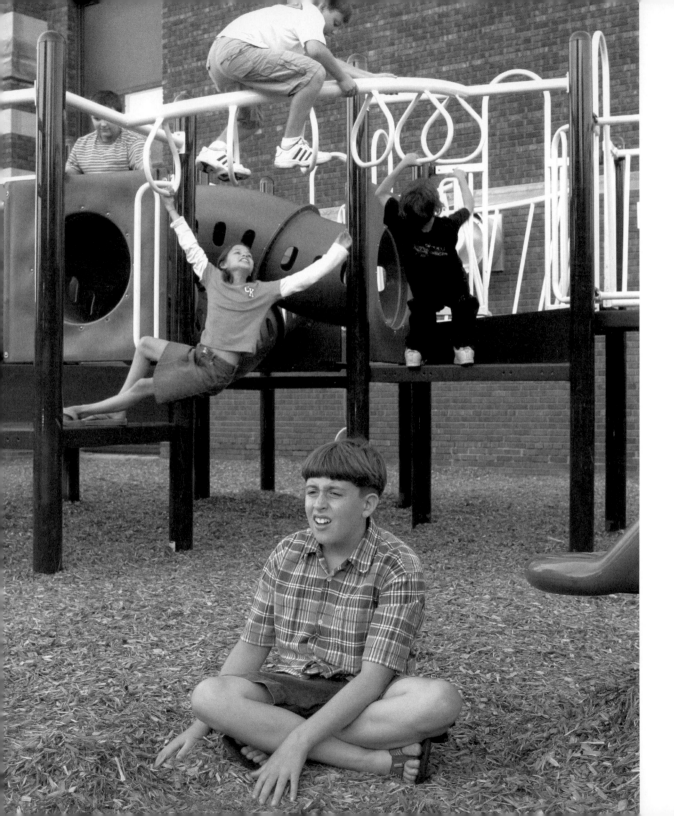

It can be hard for
my best friend
Will and other kids
with autism to make
friends because
they have a tough time
communicating with
other kids.

Communicating means letting others know what you want or need. It also means letting your friends know that you are happy and having fun.

Most people communicate by using words as well as body language such as frowns, or sad or happy faces.

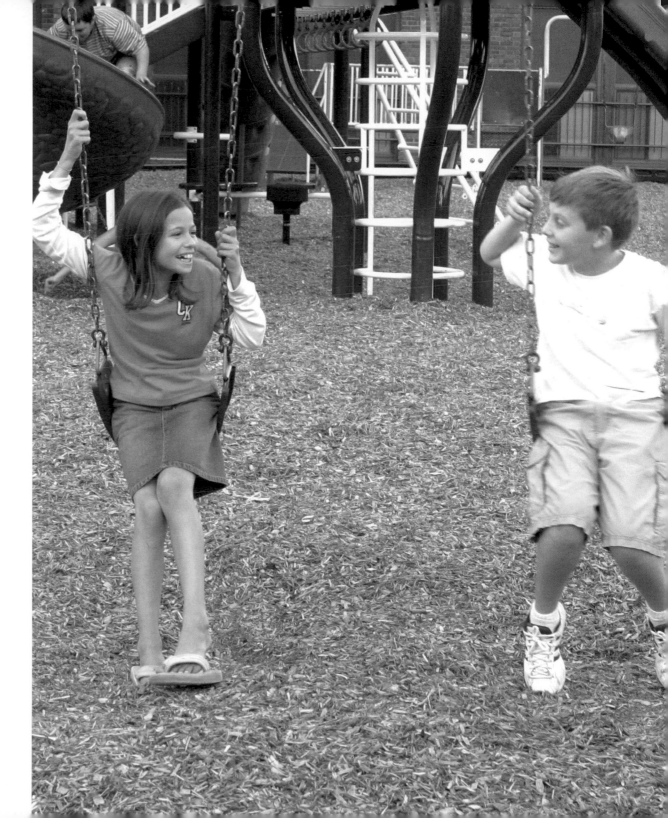

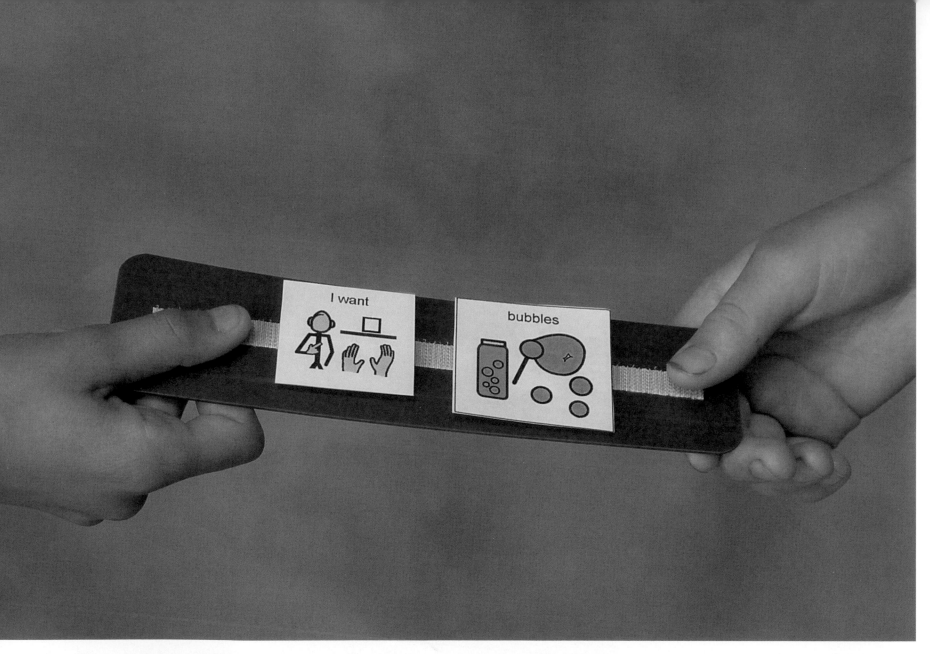

Some kids with autism talk, but some do not. Kids with autism who do not talk can use pictures to communicate with other people.

Will can talk, but he uses a picture schedule to help him understand what he is going to do at school each day. A picture schedule is pretty much like any other schedule but it uses pictures instead of, or in addition to, words. My friends and I like to look at the picture schedule too, so we know what is going to happen next.

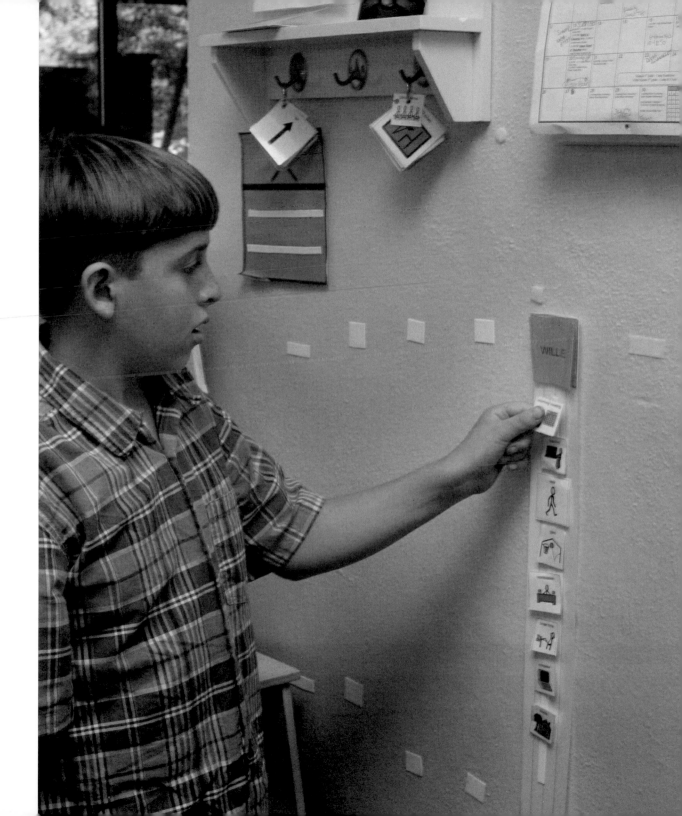

Some kids with autism have a tough time understanding emotions. They feel happy, sad, mad and scared just like you and I, but it can be hard for them to understand why they feel that way.

There are some ways that my best friend Will and I are different, just like there are ways that you and your friends are different.

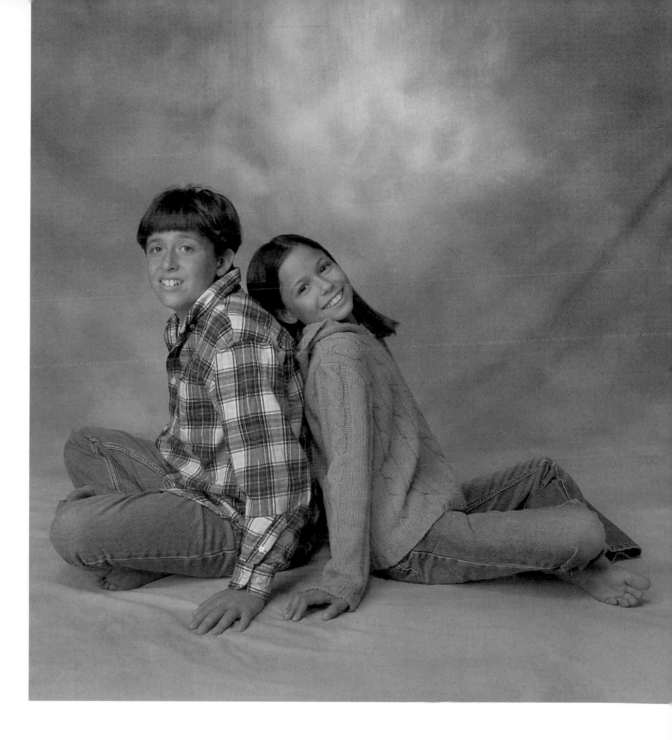

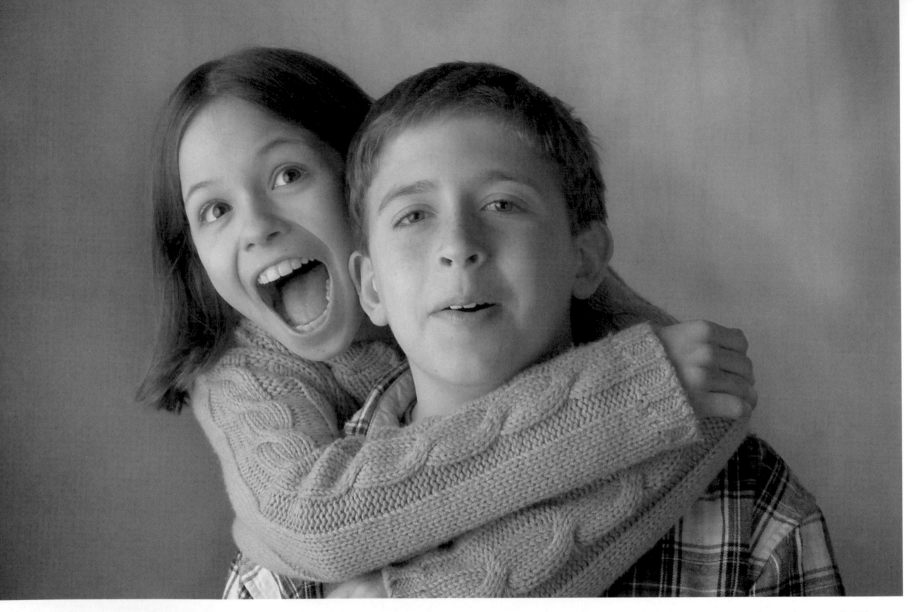

If everyone in the world were exactly the same, it would be very boring. I like to have friends that are different from me because we can all learn new things from each other.

Understanding our friends with autism can help us all learn about what it means to be a friend. Autism is not the wrong way of thinking, it's just another way of thinking.

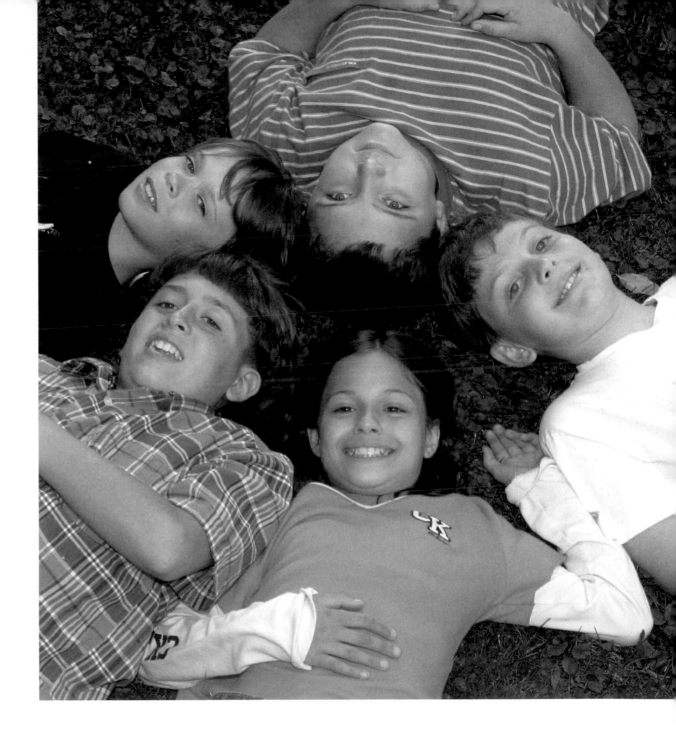

Ideas for How to Use My Best Friend Will at Home or at School

This book is geared toward Pre-K through late-elementary children and their families. In addition to being read purely as a wonderful story of a heart-warming friendship between two young children, the book may be used by special education teachers, general education teachers, school counselors, school psychologists, parents or others who would like to spread awareness and acceptance of autism spectrum disorders.

Tips for Teachers

* When conducting an "autism inservice" for students in a general education classroom, it is important to talk to the parents of the child with autism ahead of time and make sure you have permission to use the word *autism* to describe the child. Some people prefer not to use the label of autism; instead they choose to describe the characteristics of the child. It is also up to the parents to decide whether they want their child with autism to be present in the classroom during the discussion, so please be sure to address this issue ahead of time as well.

* When doing an "autism inservice" with young children, it is a good idea to start out by first talking about how we are all different from one another (hair color, eye color, abilities, etc.). Then talk about how we are all the same. It is fun to brainstorm with the students about these things. The TEACCH (Treatment and Education of Autistic and related Communication handicapped CHildren, University of North Carolina) website (http://www.teacch.com/teacch_e.htm) has great ideas. Another informative website, which includes an Autism Awareness Unit for Kids, is http://www.angelfire.com/pa5/as/autismunit/AutismAwarenessfor Kids.htm

* Another great idea is to add music to presentations geared toward younger children to help them learn about autism. For example, Jeanne Lyons (a mother of a child with autism) has created a CD titled "Gather Stars for Your Children" (1997). The CD contains several autism-related songs that can be tied into a presentation on children with autism and their unique characteristics. For further information, visit Jeanne Lyons' website, www.bitlink.com/jeannelyons.

* After discussing in general how we are the same and how we are different, discuss autism in particular. The following is a list of questions and answers found in the Autism Society of Minnesota's "Autism Awareness Program" packet. This program is a helpful guide for answering questions elementary-age students may have about autism. Contact the Autism Society of Minnesota at www.ausm.org or call 1-651-647-1083 for a packet.

◆ *What Is Autism?*
Autism is a disability that affects the way a person's brain works.

◆ *How Do You Get Autism?*
No one knows why some people have autism. Scientists and doctors are still trying to find out what causes autism.

◆ *Can I Get Autism?*
No, autism is not contagious. People who have autism were born with autism.

◆ *Why Do Kids with Autism "Act" That Way? (e.g., scream, hit, yell, flap, spin, or do or say the same things over and over)*
There are many reasons why kids with autism may act in unusual ways. Remember that autism affects the way a person's brain works. Just like you, kids with autism can become frustrated and angry, but they often can't tell us why. Instead of using words, they may use actions to tell us, such as screaming or yelling.

Some kids with autism do not feel, hear or see things the same way most of us do. For example, the sound of a school bell may "hurt" their ears. Some kids with autism get upset when things change because new or different things can be scary or difficult for them to handle. As a result, they may have a hard time controlling their behavior because they do not understand what they are supposed to be doing.

Some kids with autism have difficulty making friends, but teachers and parents help them learn better ways to understand and communicate with others.

◆ *How Can I Help Someone with Autism?*
You can begin by being a friend. For example, you can:
- Accept your friend's differences
- Protect your friend from things that bother him or her
- Talk in short sentences and use gestures
- Use pictures or write down what you want to say to help your friend understand
- Join your friend in activities that interest him or her
- Be patient – understand your friend doesn't mean to bother you or others
- Invite your friend to play with you and join group activities
- Help other kids learn about autism by telling them about your special friend

Reprinted by permission, Autism Society of Minnesota

✻ After talking about how to be a friend to someone with autism, discuss using "helping" rather than "hurting words." In order to demonstrate both, you may want to use the following activity developed by Jeanne Lyons (Tunes for Knowing and Growing, Inc.). Lyons emphasizes the importance of using positive, directive words and showing neurotypical children how to use them as a way to encourage mutually beneficial friendships with peers with autism spectrum disorders.

◆ *Cotton Ball Activity*
 • Place two laundry baskets about 10-15 feet apart. One of the baskets contains cotton balls. Provide a blindfolded volunteer with a large ladle and ask him or her to scoop up the cotton from the basket and walk to the other basket and drop the cotton balls in (I usually have the teacher do this). This person represents someone with autism spectrum disorders.

 • Talk about how you made it difficult for the volunteer to receive and understand all of the information from her senses by blindfolding her. Help the volunteer (teacher) by only telling her what she is doing wrong. "Don't do that ... Stop doing it that way ... NO ... What is wrong with you? ... You are not very good at this!" Afterwards, ask the students and the volunteer if these comments were helpful. Explain that these are the kind of comments people with autism often receive. Explore whether or not negative words help someone figure out what to do.

 • Now, talk to the children about how and why they should use "helpful" words rather than negative words. In doing so, ask who likes it when they are understood by others. Repeat the cotton ball activity, and this time tell the volunteer what to do to get the cotton balls from one basket to the other (for example, "Turn to the left ... Walk 5 steps ... Bend down and use the spoon to feel the basket ... You can do it ... You are close ... Try again ... You've got it ... Great!"). You may even want to help the volunteer do the job by using hand over hand. At the end, talk again about helpful vs. hurtful comments.

Reprinted by permission, Jeanne Lyons

✻ Upon completing the discussion about autism spectrum disorders, have the children participate in sensory awareness activities. You may want to utilize your occupational therapist as a resource to help explain these activities to the students. Break the children up into about five groups and ask them to go to different "centers" led by an adult. These centers are designed to allow typical students to experience what it might be like to have sensory processing differences. You can also refer to Carol Gray's *The Sixth Sense II* (2002) for additional ideas for autism awareness activities. On the following page, you will find a variety of activities developed by Catherine Faherty, Asheville TEACCH Center. The activities are outlined in their entirety in her "Understanding Friends" Program at www.teacch.com., and are reprinted here by permission.

◆ *Fine-Motor Activity:* Each child wears large cloth garden gloves or ski gloves and tries to string beads or assemble nuts and bolts. The goal of this activity is to demonstrate the difficulty some kids may have when their "small muscles" are not working in a typical manner. It can be hard to use these muscles when your brain is not getting all of the correct information from the small muscles (e.g., finger muscles). This is the case for some children with autism spectrum disorders.

◆ *Visual Activity:* Each child wears a pair of safety goggles (with obstructed view because petroleum jelly has been smeared on the lenses or they have been scratched by sandpaper). Ask students to write sentences on the lines on a sheet of paper, read the print in a book or copy words from a book. The goal of this activity is to demonstrate how difficult it is to write or read if your eyes are not sending the correct information to the brain. This is the case for some children with autism spectrum disorders.

◆ *Perceptual and Sensory/Tactile Activity:* Place an 8-10 foot length of masking tape on the floor and have each student walk on the line while holding binoculars on their eyes (backwards). This distorts perception. The goal of this activity is to demonstrate what it is like if your brain is not receiving the right amount of information about where your body is in space. This can make it difficult to walk and keep your balance. Again, this is a problem for many children with autism spectrum disorders.

◆ *Perceptual & Sensory/Tactile Activity:* Using several strips of yarn instead of rope, have the kids "jump rope." The perception of the weight of the rope is distorted, making it difficult both to swing and to jump rope. The goal of this activity is to demonstrate what it might be like if your brain is not getting enough information to predict what is going to happen. You can feel quite uncoordinated if you can't predict how fast or slow things are moving around you. This is how many children with autism spectrum disorders feel.

Recommended Readings

Children's Books

All About My Brother, Sarah Peralta (Shawnee Mission, KS: Autism Asperger Publishing Company, 2001).

Amazingly Alphie, Roz Espin and Beverly Ransom (Shawnee Mission, KS: Autism Asperger Publishing Company, 2003).

Andy and His Yellow Frisbee, Mary Thompson (Bethesda, MD: Woodbine House, 1996).

Aspergers: What Does It Mean to Me? Catherine Faherty (Arlington, TX: Future Horizons, 2000).

Ian s Walk, Laurie Lears and Karen Ritz (Morton Grove, IL: Albert Whitman & Company, 1998).

Jackson Whole Wyoming, Joan Clark (Shawnee Mission, KS: Autism Asperger Publishing Company, 2005).

Looking After Louis, Polly Dunbar and Lesley Ely (Morton Grove, IL: Albert Whitman & Company, 2004).

Oliver Onion, Diane Murrell (Shawnee Mission, KS: Autism Asperger Publishing Company, 2004).

Special People, Special Ways, Arlene Maguire (Arlington, TX: Future Horizons, 2000).

This Is Asperger Syndrome, Elisa Gagnon and Brenda Smith Myles (Shawnee Mission, KS: Autism Asperger Publishing Company, 1999).

Tobin Learns to Make Friends, Diane Murrell (Arlington, TX: Future Horizons, 2001).

Trevor, Trevor, Diane Twachtman-Cullen (Cromwell, CT: Starfish Press, 1998).

When My Autism Gets Too Big, Kari Dunn Buron (Shawnee Mission, KS: Autism Asperger Publishing Company, 2003).

Teacher Resources

Gather Stars for Your Children: Songs That Teach Social Skills and Encourage a Welcoming Attitude Among Classmates (CD; cassette), Jeanne Lyons (Marietta, GA: Jeanne Lyons Tunes For Knowing And Growing, 1997).

Pathways to Play! Combining Sensory Integration and Integrated Play Groups—Theme-Based Activities for Children with Autism Spectrum and Other Sensory-Processing Disorders, Glenda Fuge and Rebecca Berry (Shawnee Mission, KS: Autism Asperger Publishing Company, 2004).

Peer Play and the Autism Spectrum: The Art of Guiding Children s Socialization and Imagination, Pamela Wolfberg (Shawnee Mission, KS: Autism Asperger Publishing Company, 2003).

The Sixth Sense II, Carol Gray (Arlington, TX: Future Horizons, 2002).

Web Sources

Autism Society of America – www.autism-society.org
The mission of the Autism Society of America is to promote lifelong access and opportunity for all individuals within the autism spectrum, and their families, to be fully participating, included members of their community. Education, advocacy at state and federal levels, active public awareness and the promotion of research form the cornerstones of ASA's efforts to carry forth its mission. The Autism Society of America website offers information regarding autism spectrum disorders and provides listings of local resources for parents and professionals.

Friend 2 Friend Program – www.friend2friendsociety.org
The Friend 2 Friend Social Learning Society is a British Columbia-based not-for-profit organization formed in 2002 for the purpose of promoting mutually rewarding friendships between children with autism spectrum and related social-communicative disorders and their peers, classmates and siblings. Their goal is to help children develop to the best of their abilities through the play and socialization that results from these friendships. They do this by providing direct services for children by visiting schools and other community settings to explain the sensory and communication challenges of autism spectrum and related disorders. They use a fun and interactive approach while teaching specific friendship skills to the typical peers. With the help of Friend 2 Friend, children enjoy learning about autism and how they can be an important part of the social success of their classmates.

Integrated Play Groups – www.wolfberg.com
Integrated Play Groups are designed to support children of diverse ages and abilities on the autism spectrum (novice players) in mutually enjoyed play experiences with typical peers and siblings (expert players). Small groups of children regularly play together under the guidance of a qualified adult facilitator (play guide). The art of guiding children in Integrated Play Groups is enacted through a carefully tailored system of support. Emphasis is placed on maximizing children's developmental potential as well as intrinsic desire to play, socialize and form meaningful relationships with peers. An equally important focus is on teaching the peer group to be more accepting, responsive and inclusive of children who relate and play in different ways. Integrated Play Groups offer natural opportunities for children to simply have fun and make friends while engaged in creative and playful activities.

TEACCH – www.TEACCH.com
TEACCH, Treatment and Education of Autistic and related Communication handicapped CHildren, has developed an approach to teaching individuals with autism that is clearly organized and structured and offers modified environments and activities. It uses functional contexts for teaching and relies heavily on visual supports in order to facilitate understanding in individuals with autism. It also uses structure and predictability to promote spontaneous communication. This approach is compatible with many other approaches in the field of autism.

Autism Asperger Publishing Co.
P.O. Box 23173
Shawnee Mission, Kansas 66283-0173
www.asperger.net

9 JAN - N - 2010